Waterdown Ontario in Photos, Saving Our History One Photo at a Time

Photography
by Barbara Raué
2012

Series Name:
Cruising Ontario

Book 7: Waterdown

Cover photo: Downtown buildings

Series Name: Cruising Ontario

Book 1: London
Book 2: Dundas
Book 3: Hamilton
Book 4: Oakville
Book 5: Chesley
Book 6: Stoney Creek
Book 7: Waterdown
Book 8: Owen Sound
Book 9: Mount Forest
Book 10: Dundalk

Other Books by Barbara Raue

Coins and Gems

Arrows, Indians and Love

The Life and Times of Barbara
Volume 1: Inventions That Have Enhanced My Life
Volume 2: Entertainment That I Have Enjoyed
Volume 3: East Coast Trip 2009

Waterdown

Waterdown is located east of the junction of Highways 5 and 6, the intersection known as Clappison's Corners.

Alexander Brown of the North West Fur Company purchased 800 acres and built a log cabin and sawmill at the top of the Great Falls in present-day Smokey Hollow in 1805. He was the first European settler in the region and was a key figure in the community throughout his lifetime. He moved down Grindstone Creek to the site of present-day LaSalle Park and built "Brown's Wharf" to export the many things created by the mills that sprang up in the Waterdown area. Brown built the first school of the village in 1815 on the site of the present-day American House, and employed Mary Hopkins as its first teacher.

Entrepreneur Ebenezer Culver Griffin arrived in 1823, purchased more than half of Alexander Brown's property, and had his property surveyed in village lots, the true beginning of the Village of Waterdown.

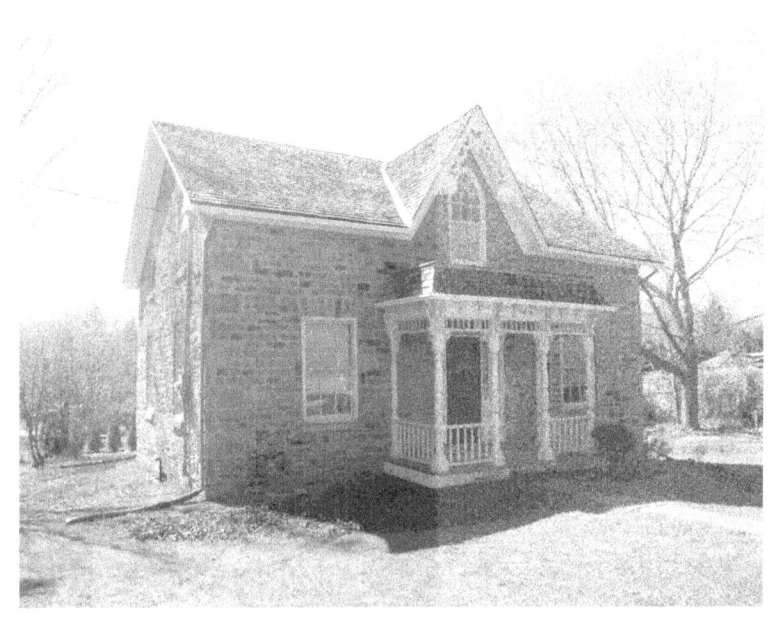

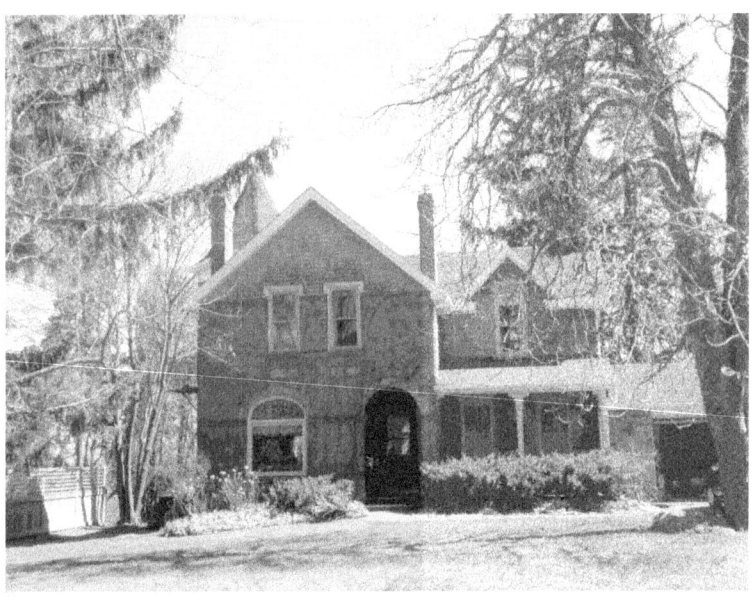

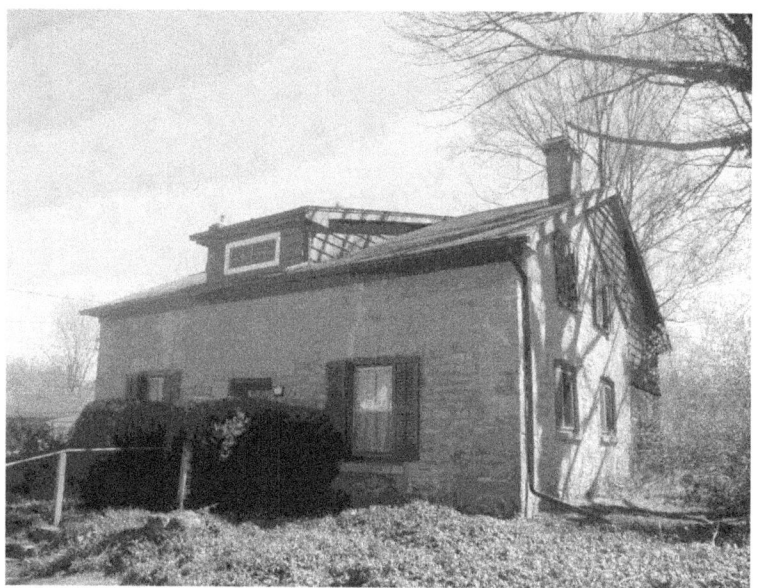

The Eastwood Place

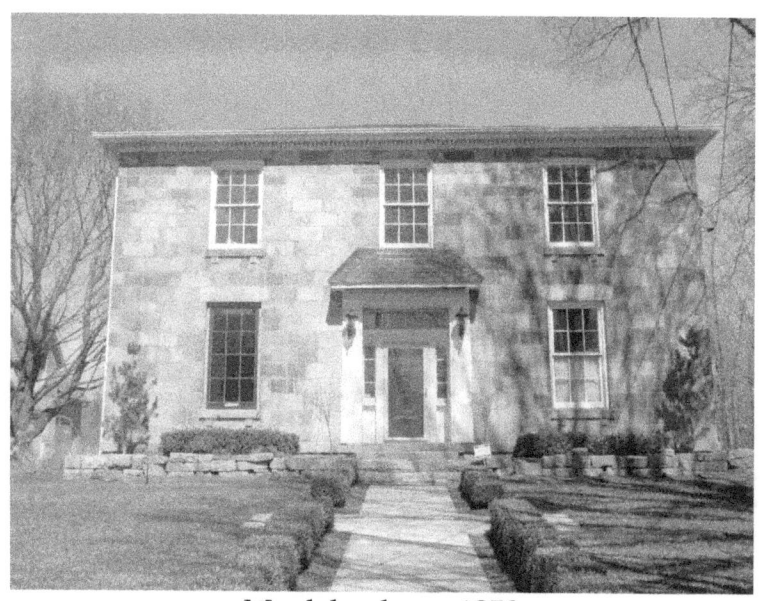

Maplebank – c. 1850
63 Mill Street

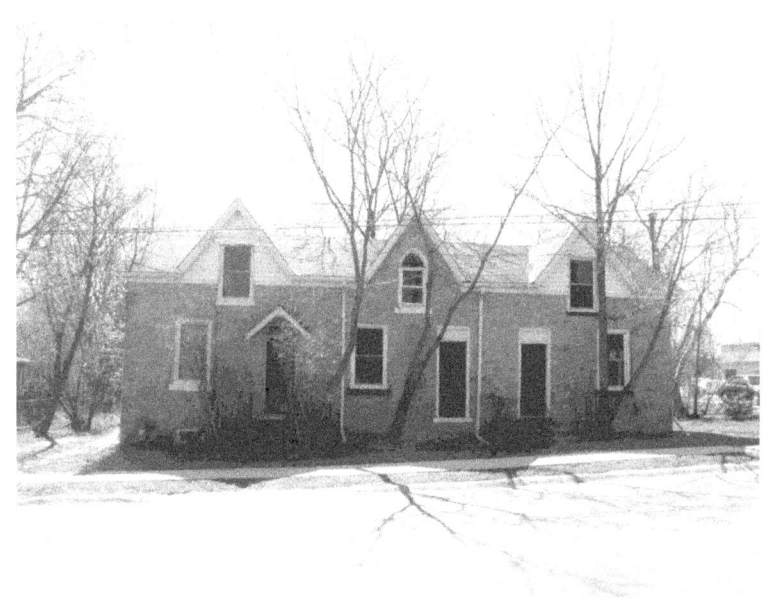

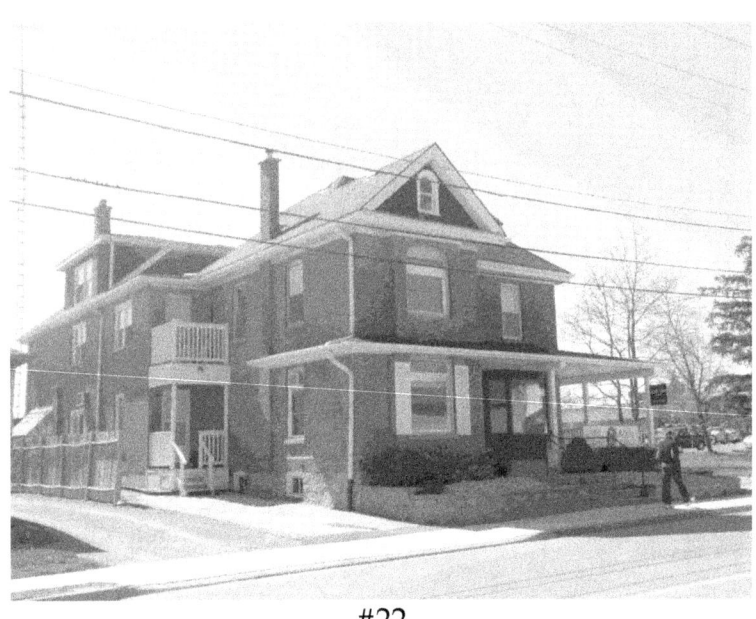

#22

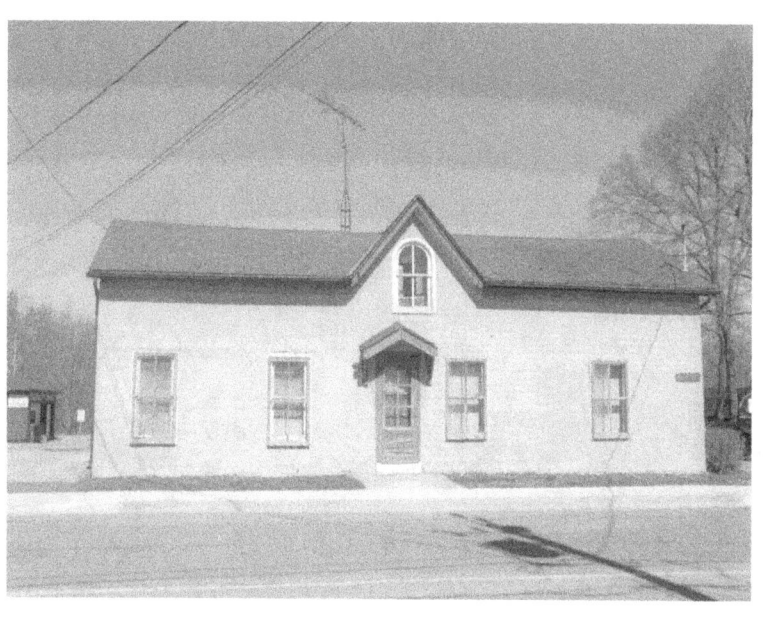

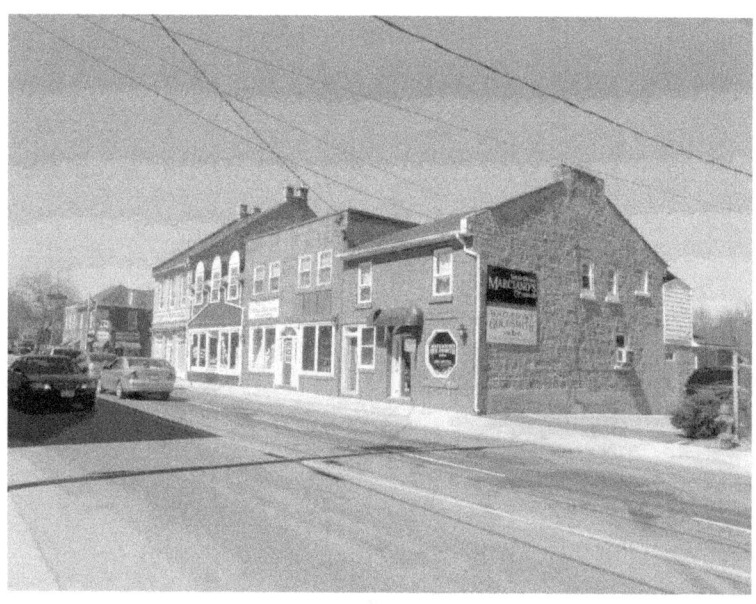

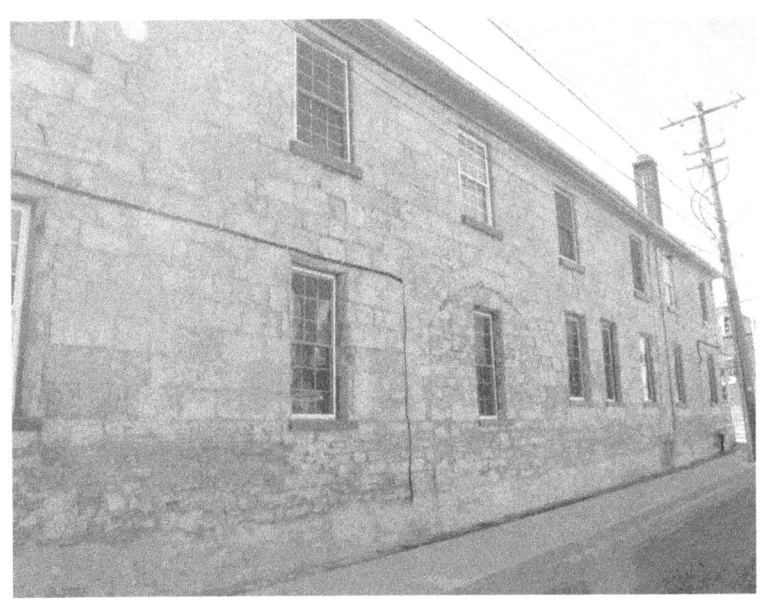

#1

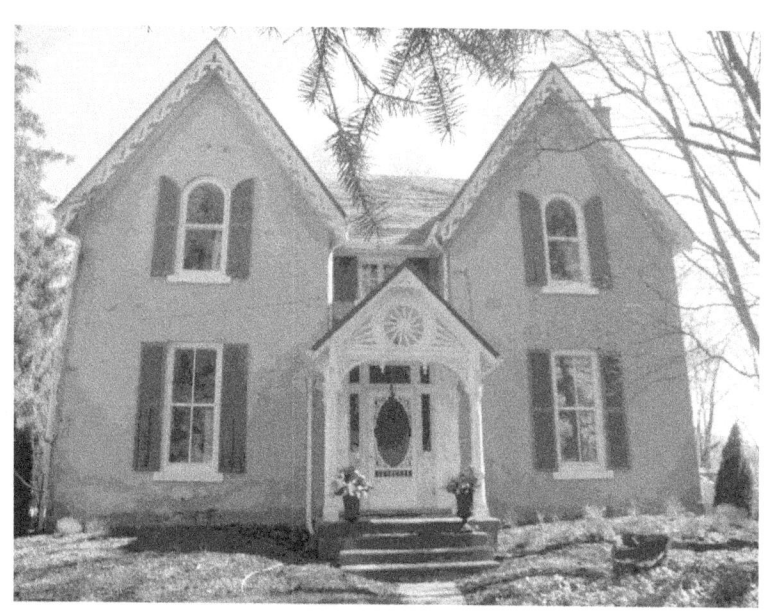

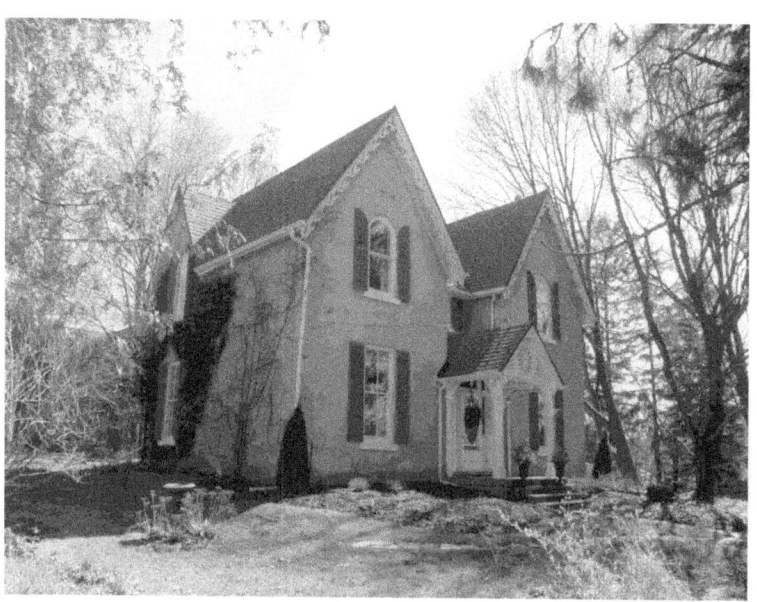

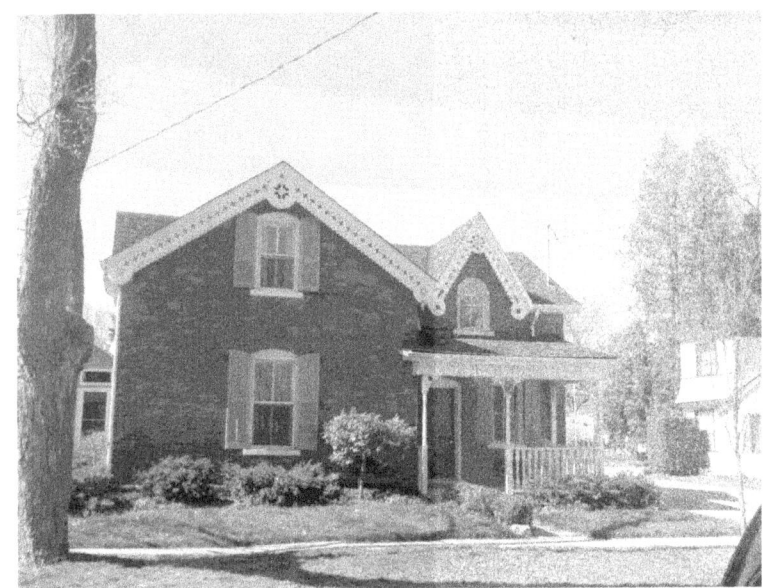

#7

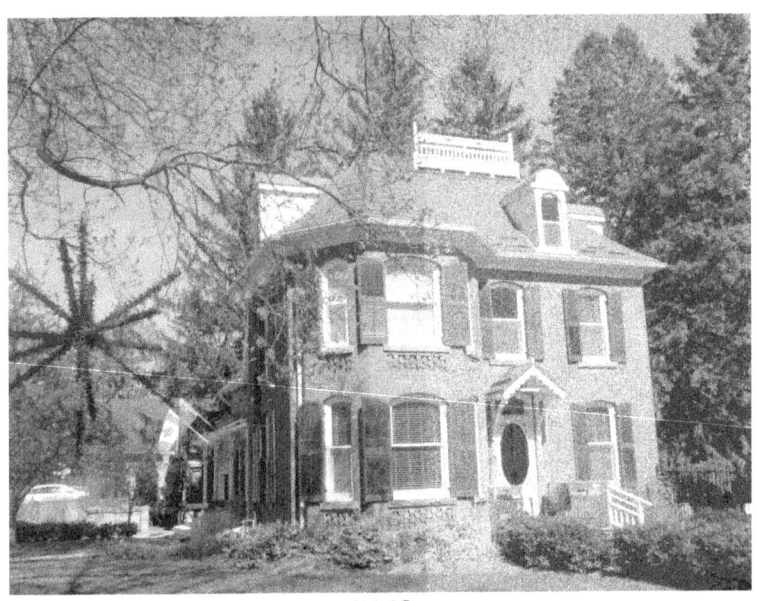

#142

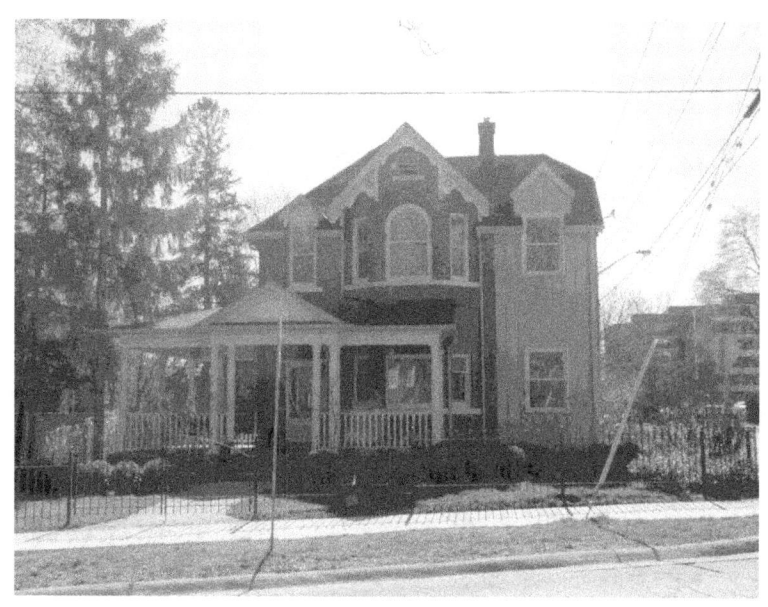

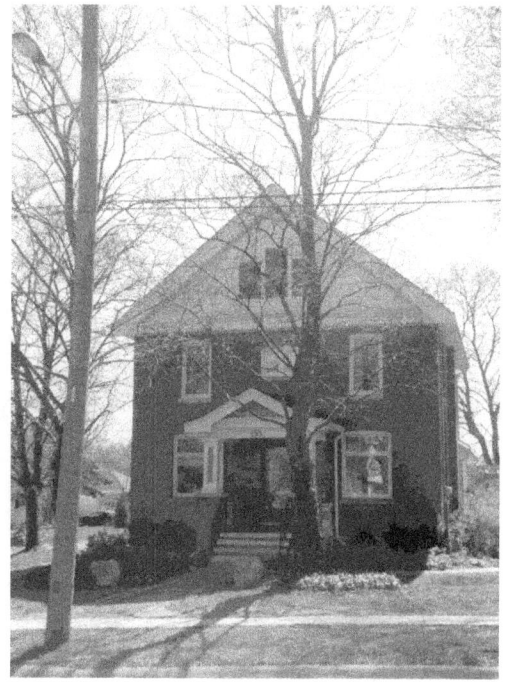

#155

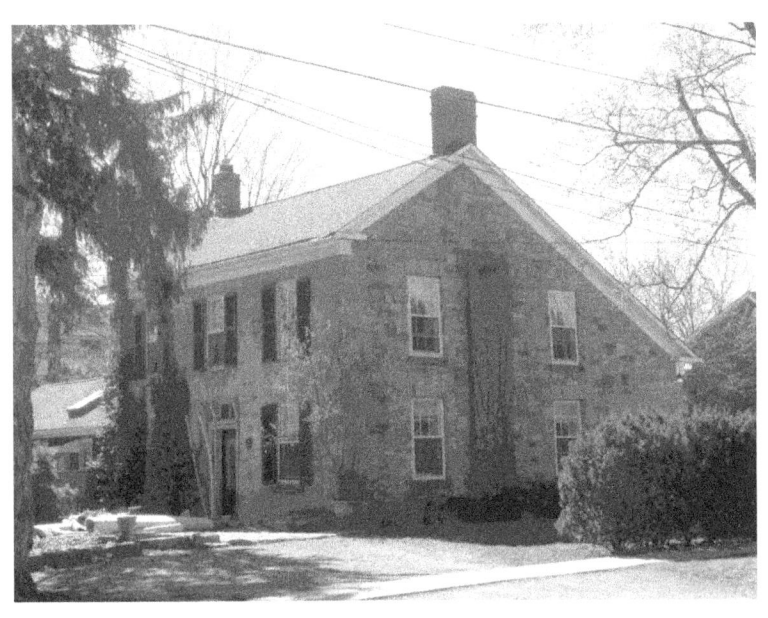

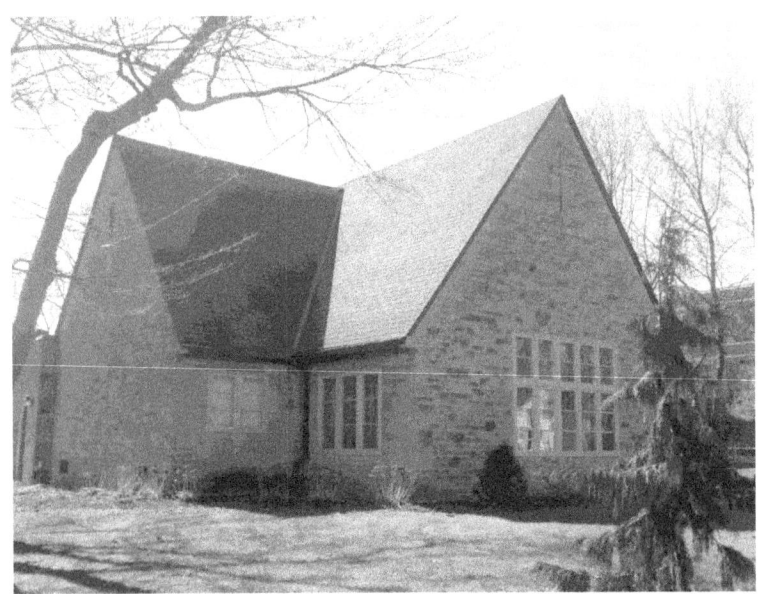

Grace Church – 157 Mill Street North

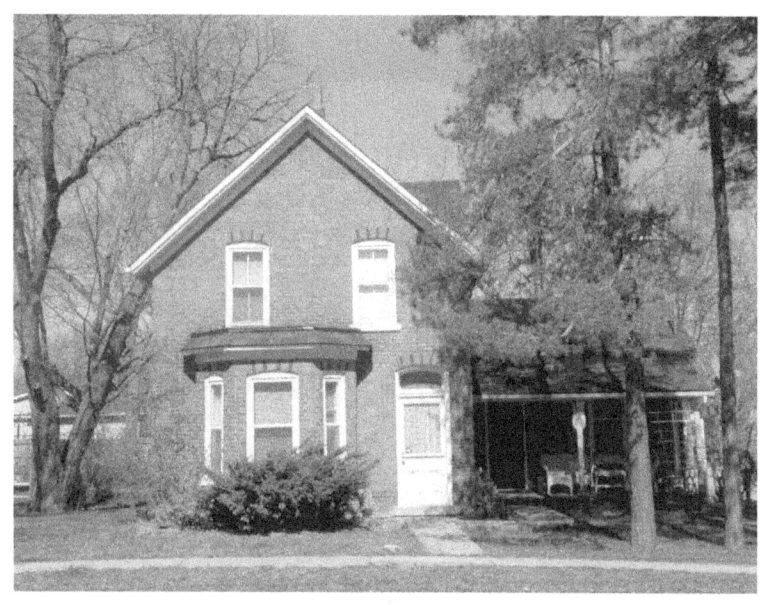

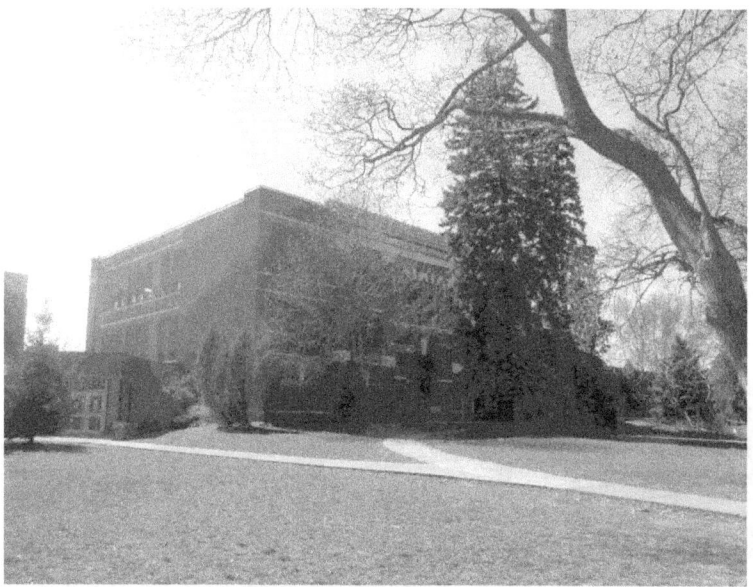

Mary Hopkins School – 211 Mill Street North
Opened in January 1921
Originally called the Waterdown and East Flamborough
Union School Section No. 3

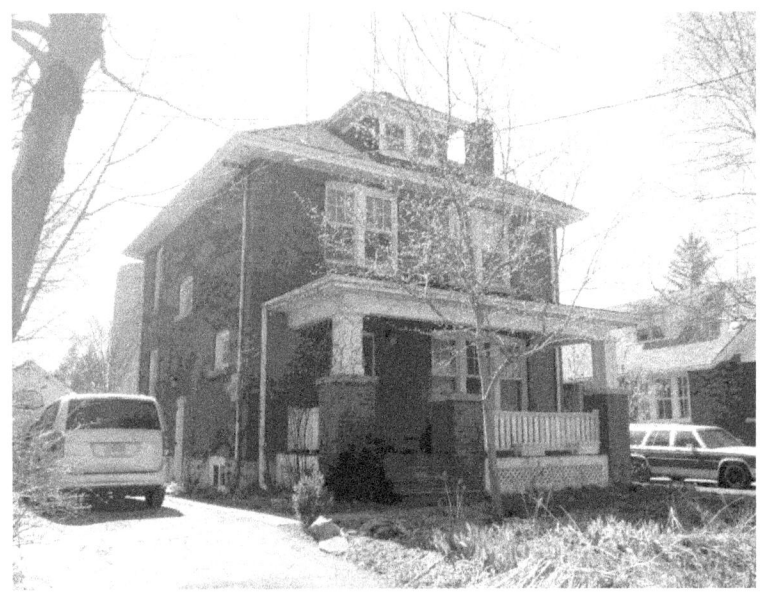

#217

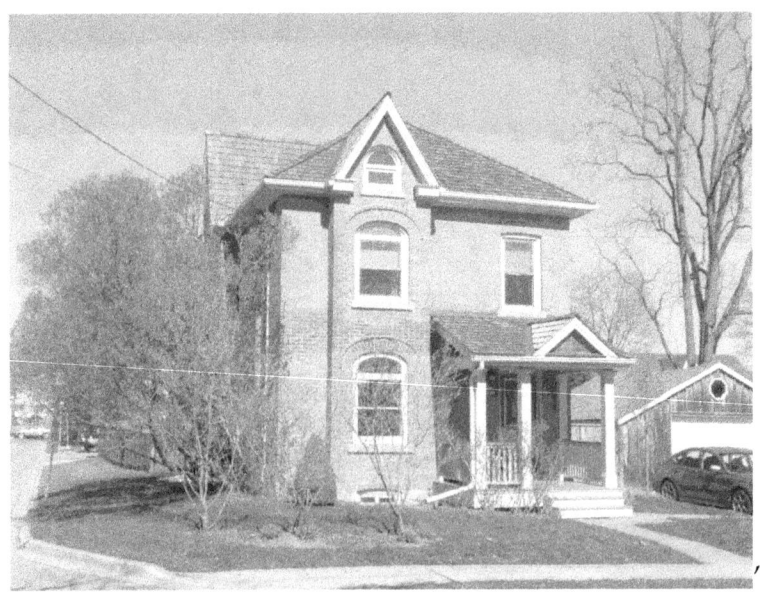

#130

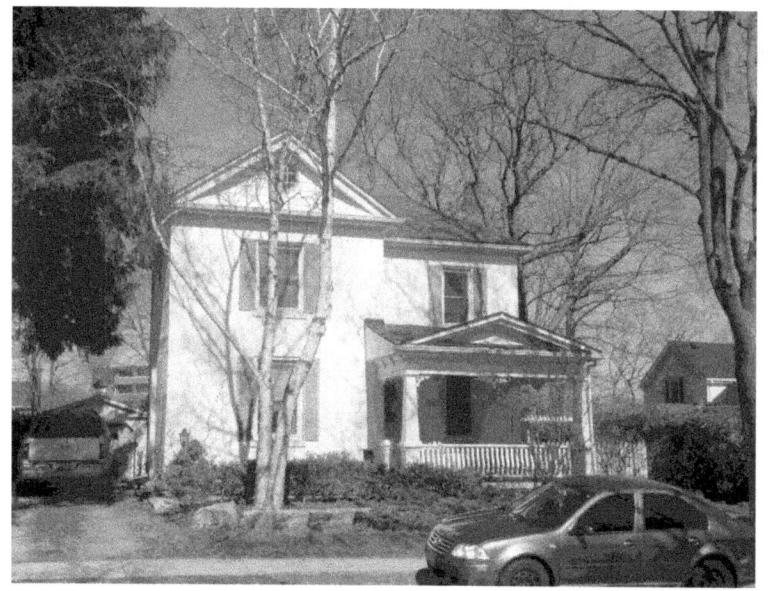

#116

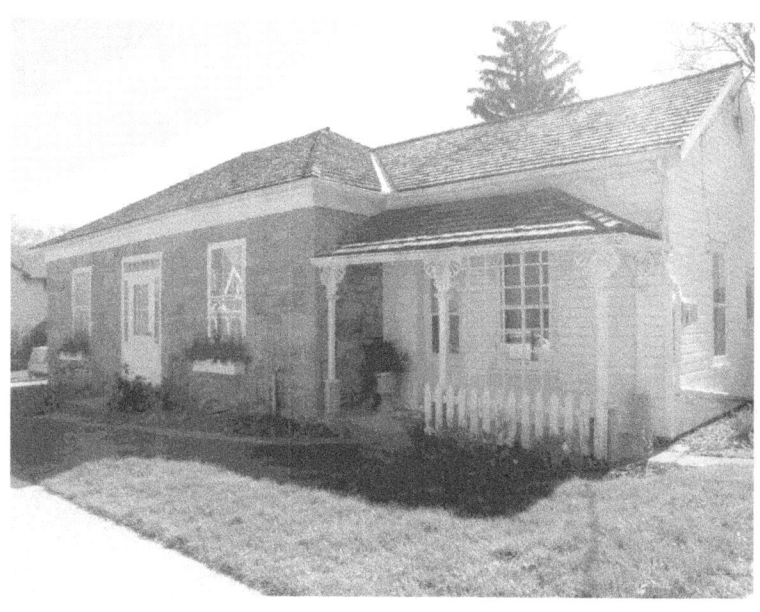

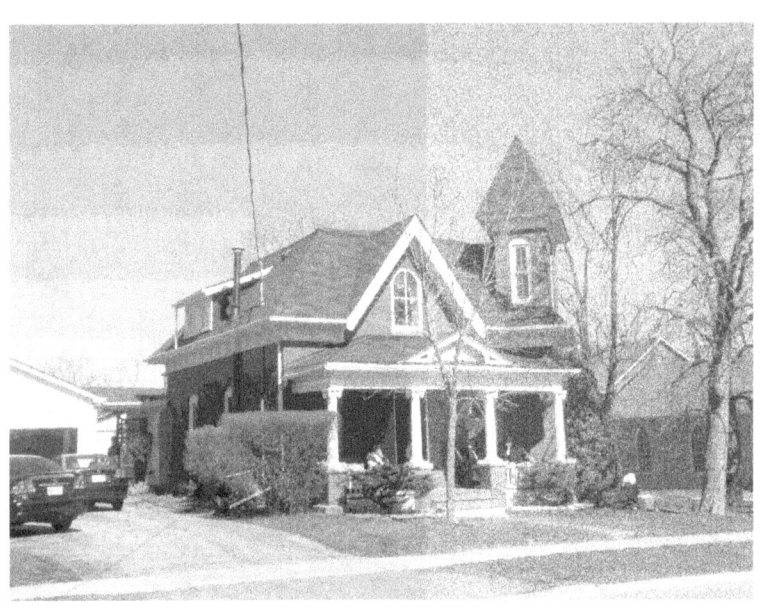

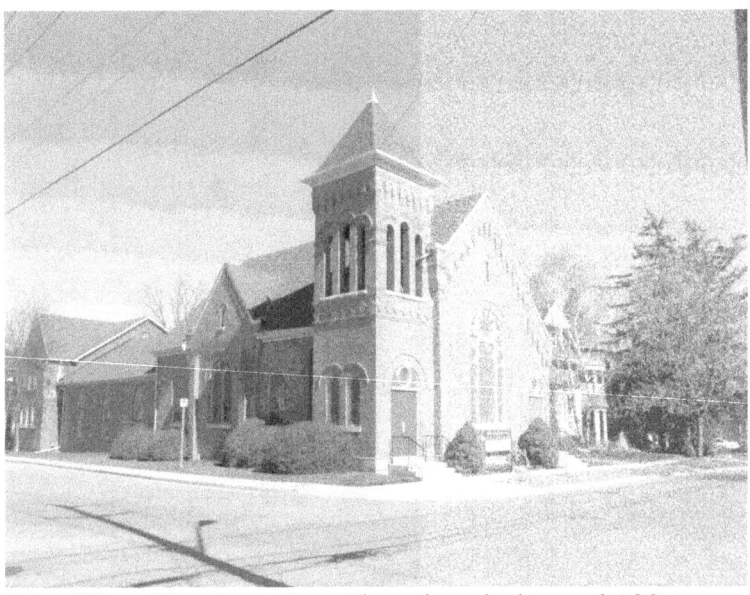

Knox Presbyterian Church – dedicated 1901
80 Mill Street

#76

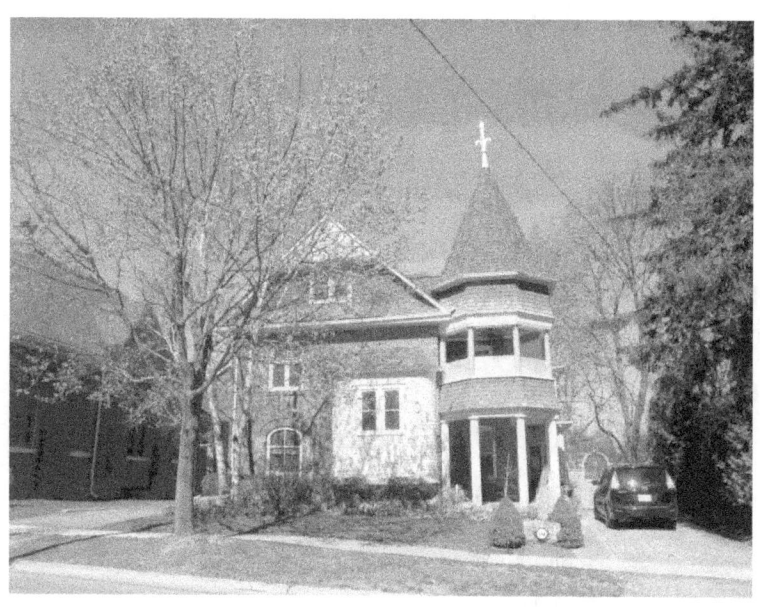

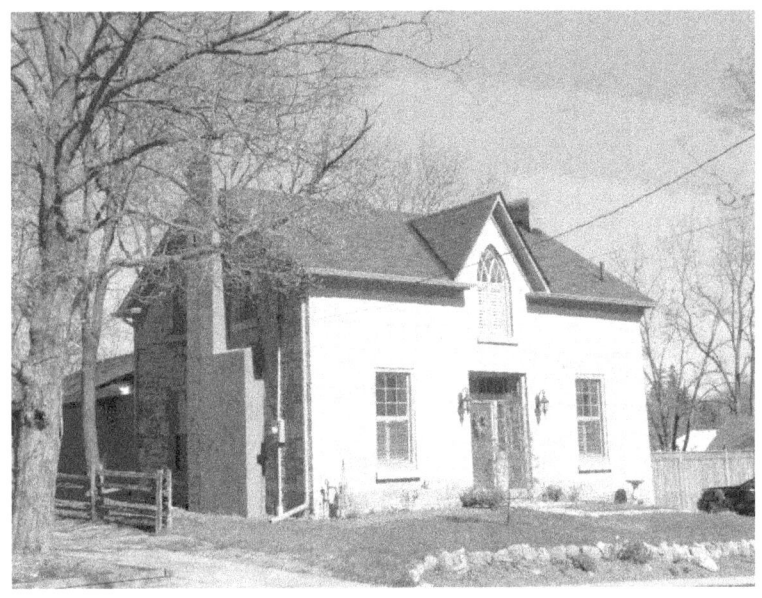

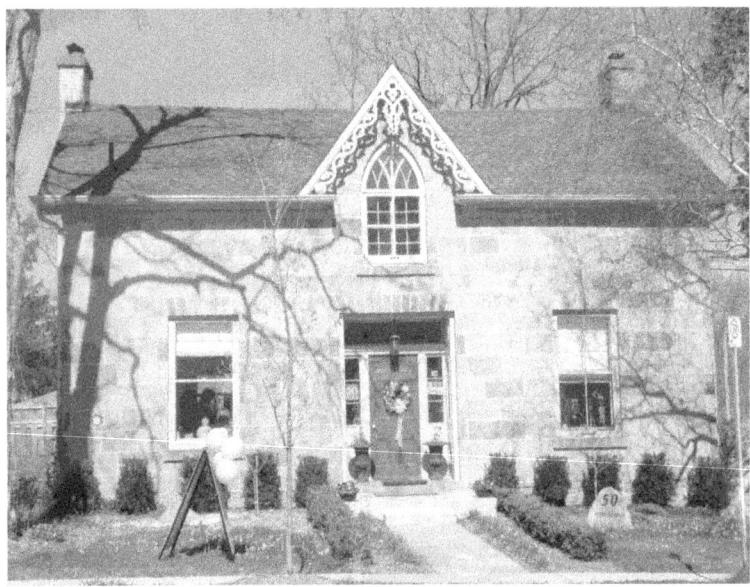

#50 Mill Street

Cut-stone house in the Ontario Vernacular style – rectangular shape, one-and-a-half storeys with centre gable with a large, ornate gothic window.

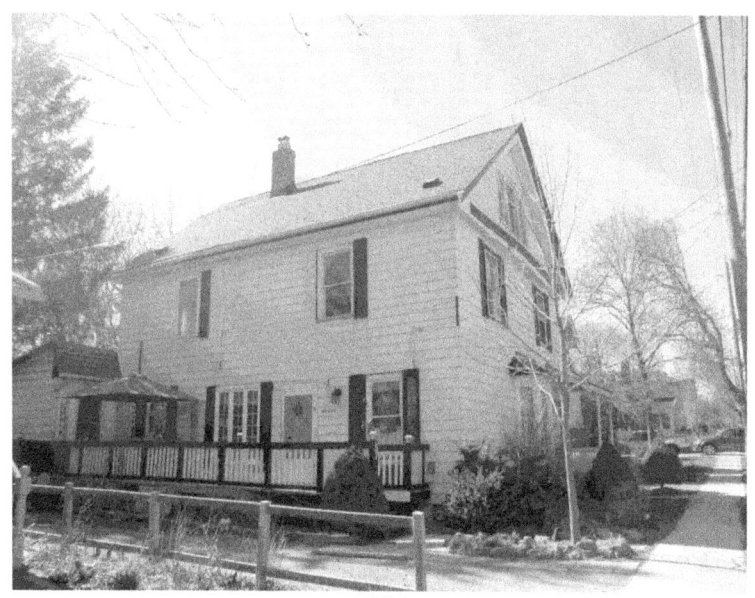

#57

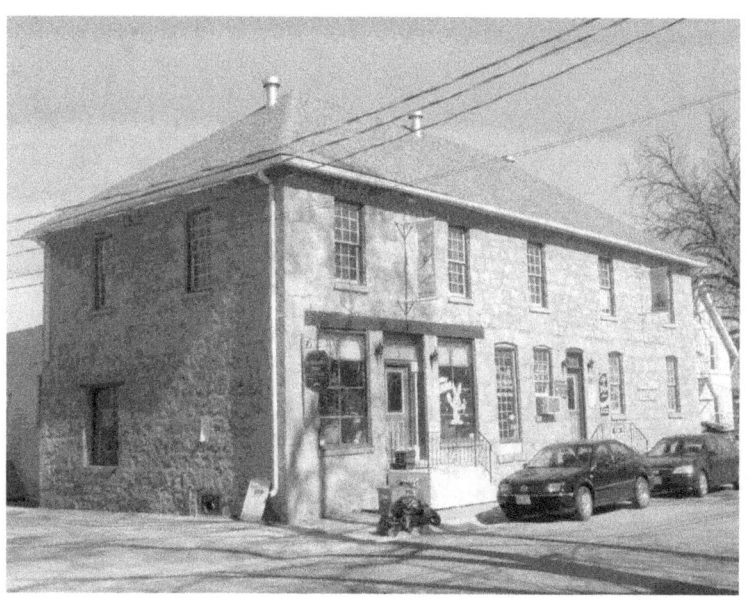

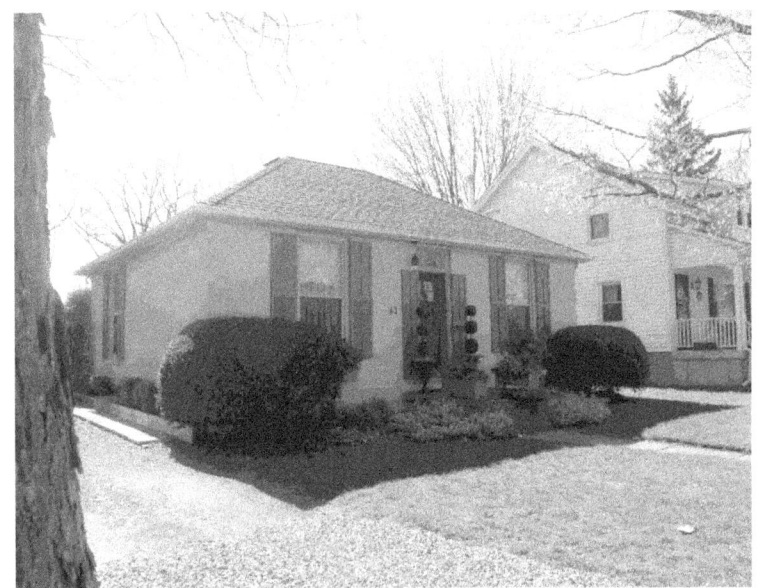

#43 Mill Street – one storey stone cottage c. 1850s

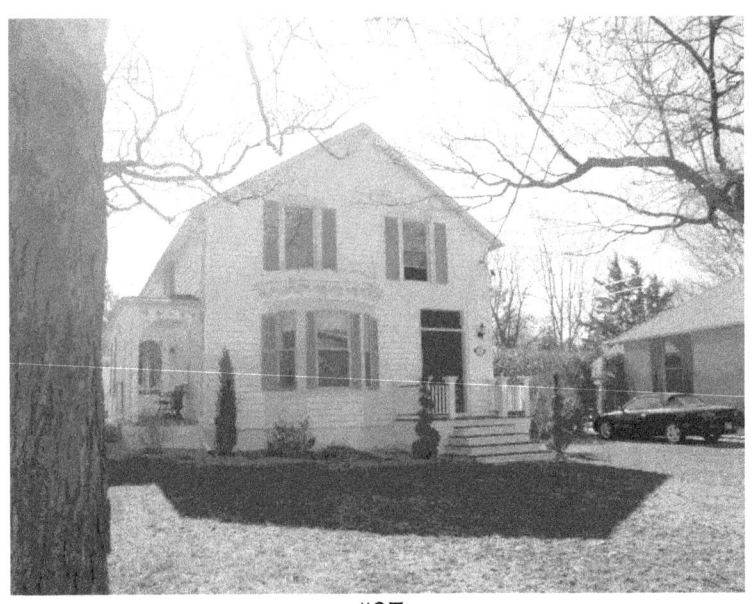

#37

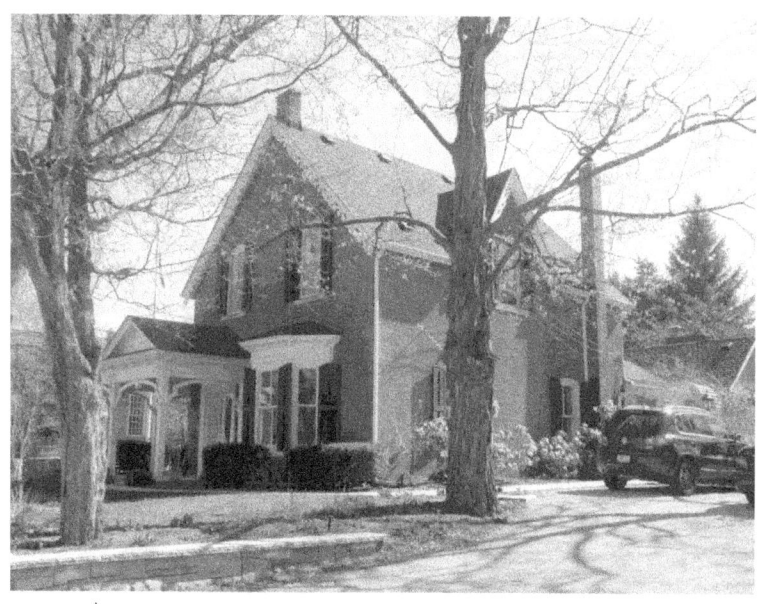

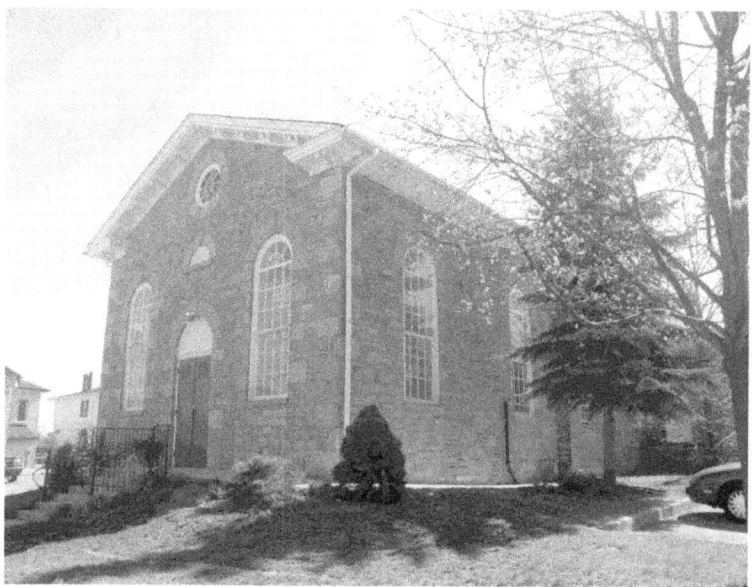

Wesleyan Methodist Church, 21 Mill Street North
Re-erected A.D. 1865

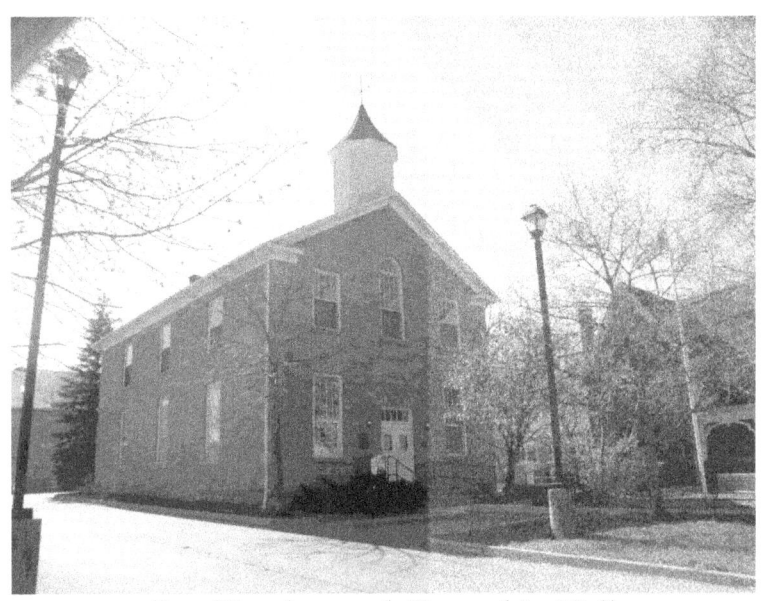

East Flamborough Township Hall
#25 Mill Street North
Built of locally quarried limestone in 1856; the cupola on the roof distinguishes it as a public building

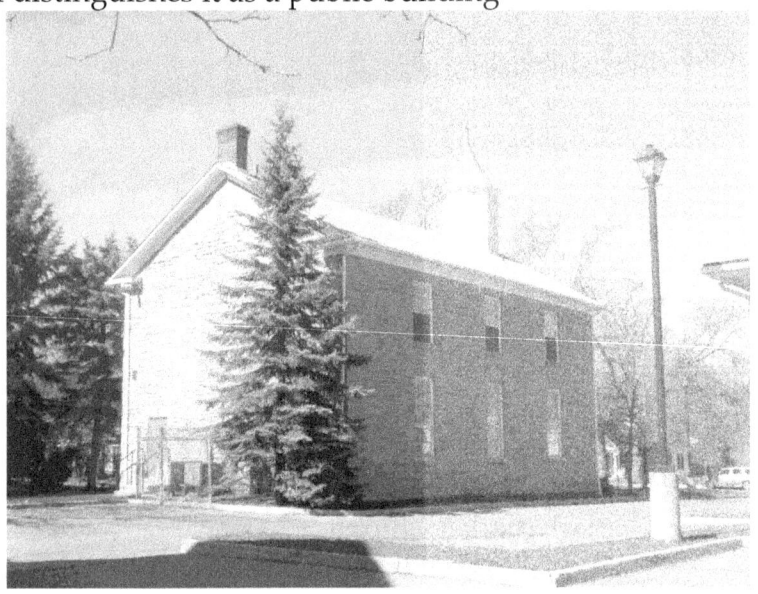

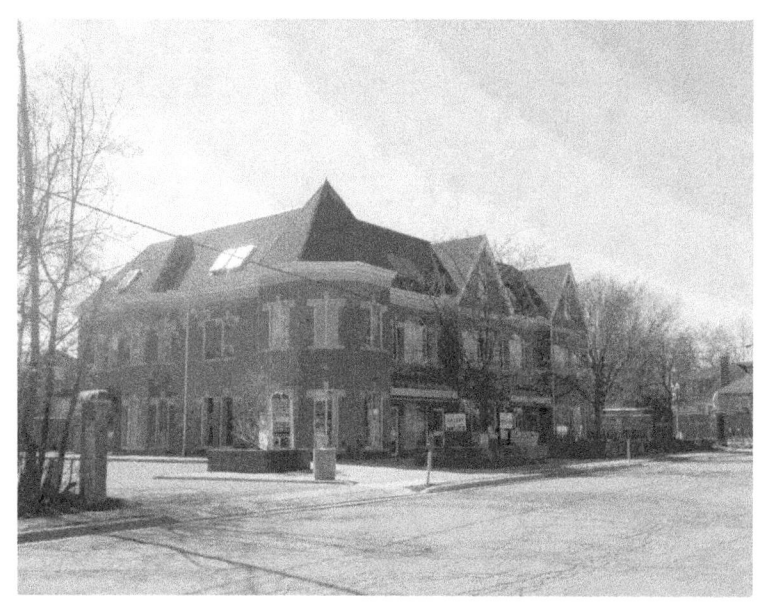

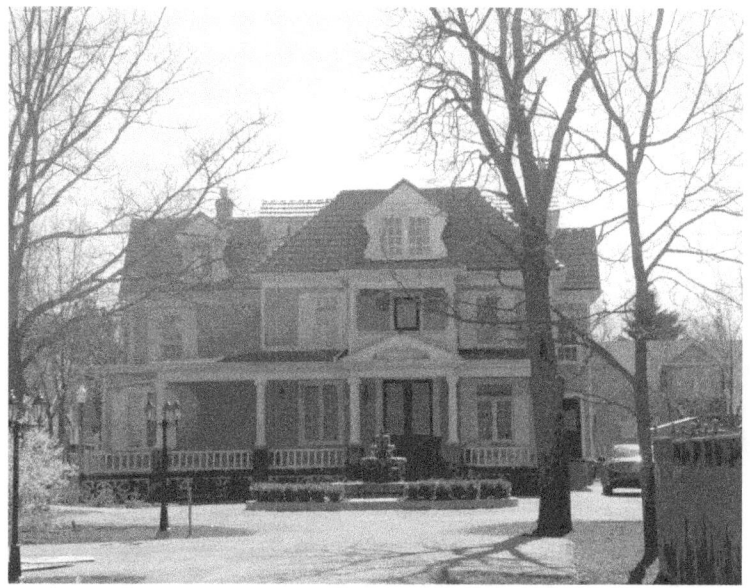

c. 1900

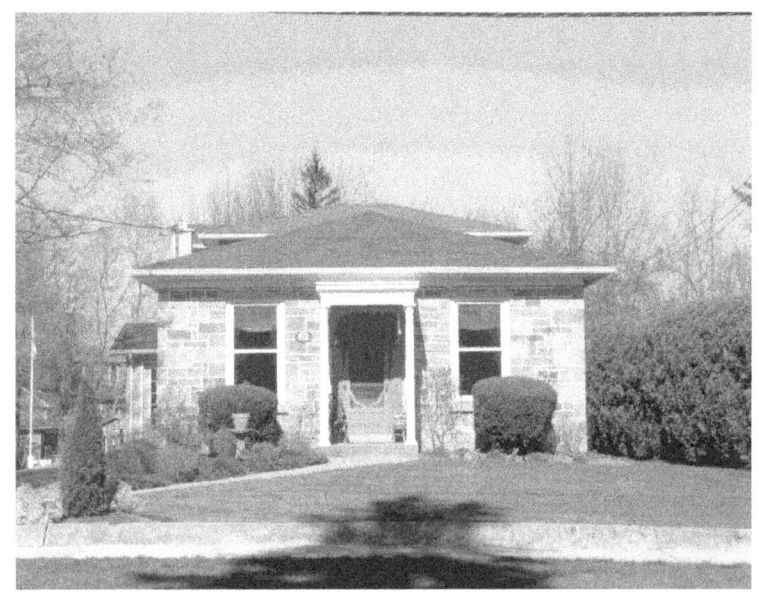

#62

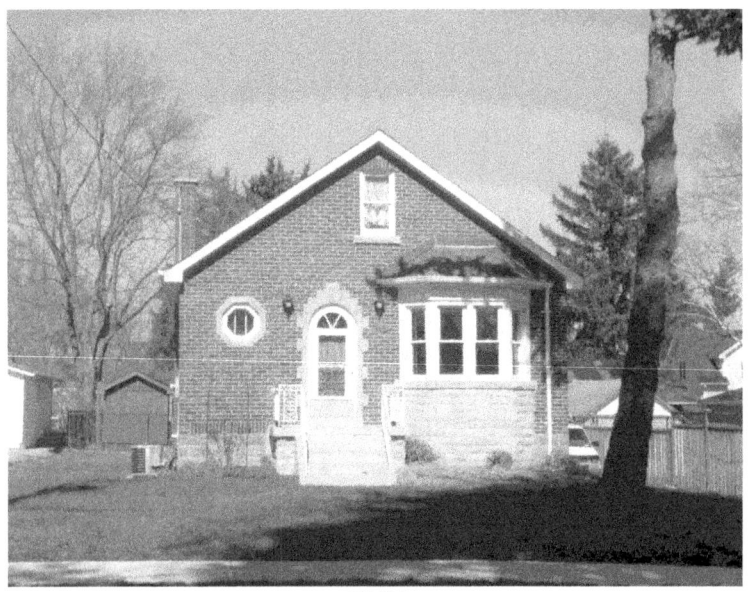

#104

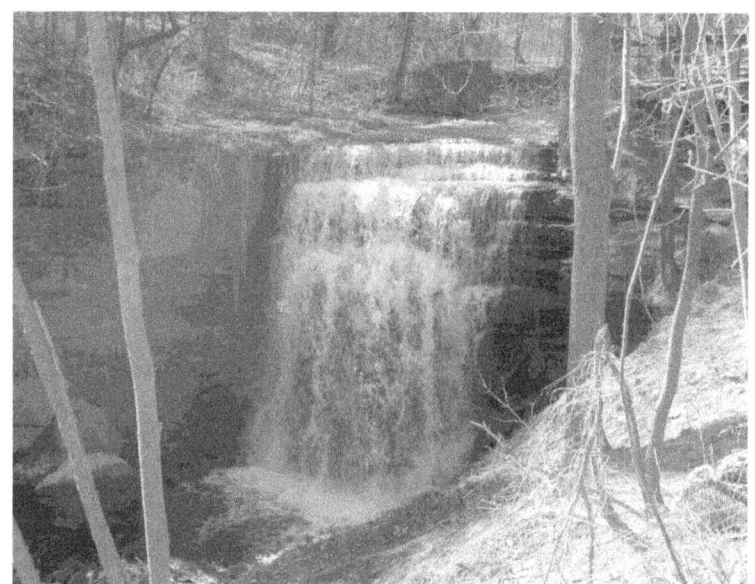

Grindstone Falls

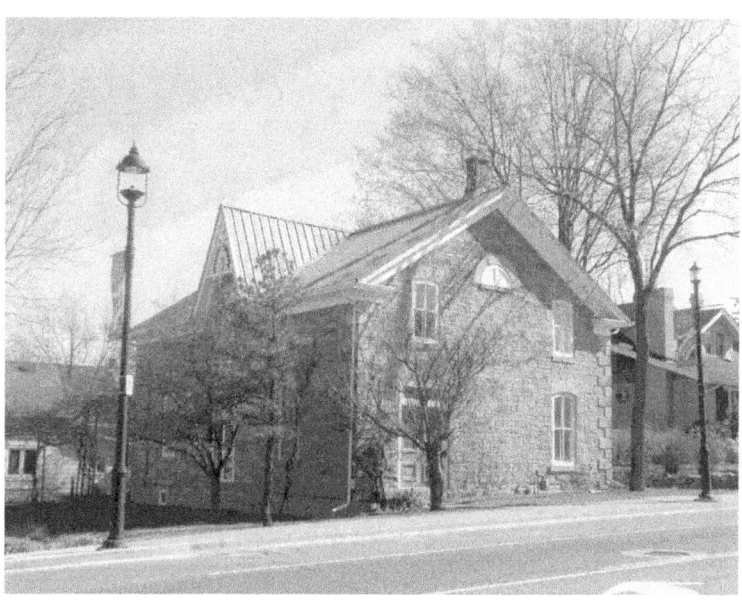

#299

#289

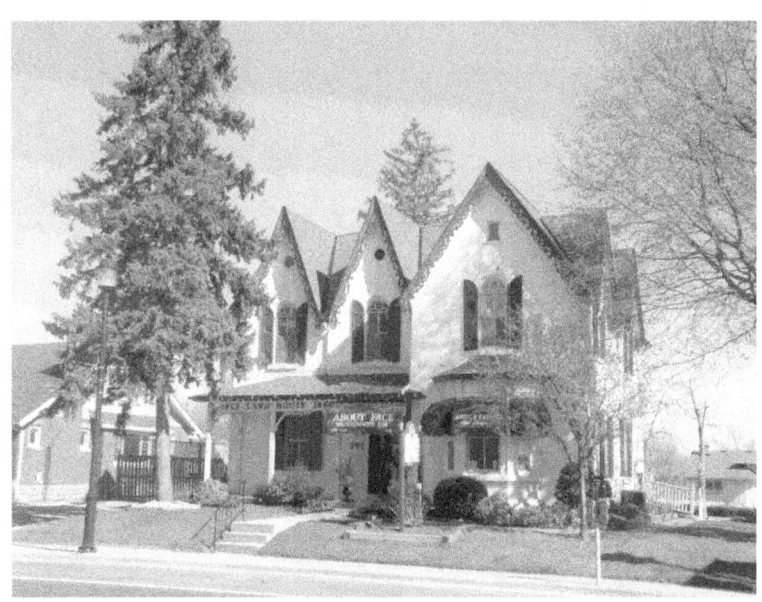

Maple Lawn House – 1860
#292

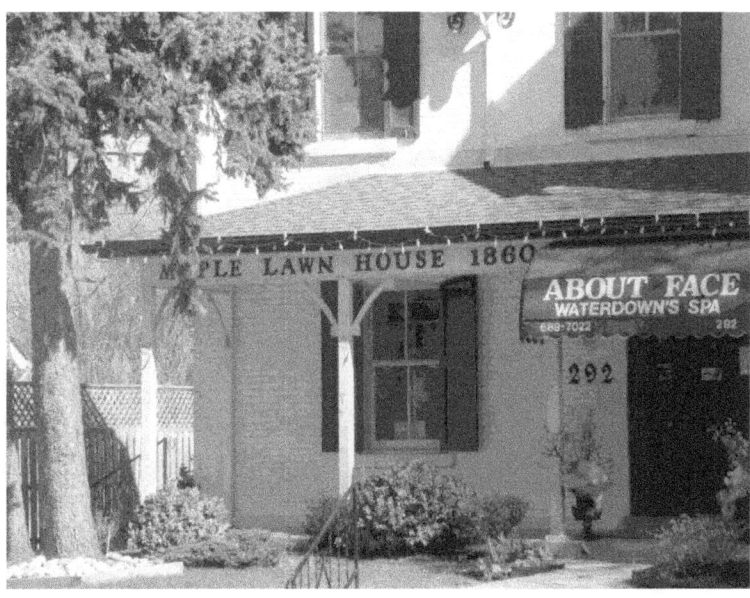

www.ingramcontent.com/pod-product-compliance
Lightning Source LLC
Chambersburg PA
CBHW061523180526
45171CB00001B/304